EVERY-THING THAT CAN HAPPEN IN A DAY

BY DAVID HORVITZ

MARK BATTY PUBLISHER · NEW YORK CITY

Everything That Can Happen In A Day
by David Horvitz

Everything That Can Happen In A Day Instructions

All photographs © the respective photographers (see page 126)

Design: Mylinh Nguyen
Cover poster: Miya Osaki

Every effort has been made to trace accurate ownership of copyrighted text and visual materials used in this book. Errors or omissions will be corrected in subsequent editions, provided notification is sent to the publisher.

Library of Congress Control Number: 2010931564

Printed and bound in China through Asia Pacific Offset

10 9 8 7 6 5 4 3 2 1 First Edition

This edition © 2010
Mark Batty Publisher, LLC
36 West 37th Street, Suite 409
New York, NY 10018, USA
Email: info@markbattypublisher.com
www.markbattypublisher.com

ISBN: 978-1-9356130-6-0

Distributed outside North America by
Thames & Hudson Ltd.
181A High Holborn
London WC1V 7QX
United Kingdom
Tel: 00 44 20 7845 5000
Fax: 00 44 20 7845 5055
www.thameshudson.co.uk

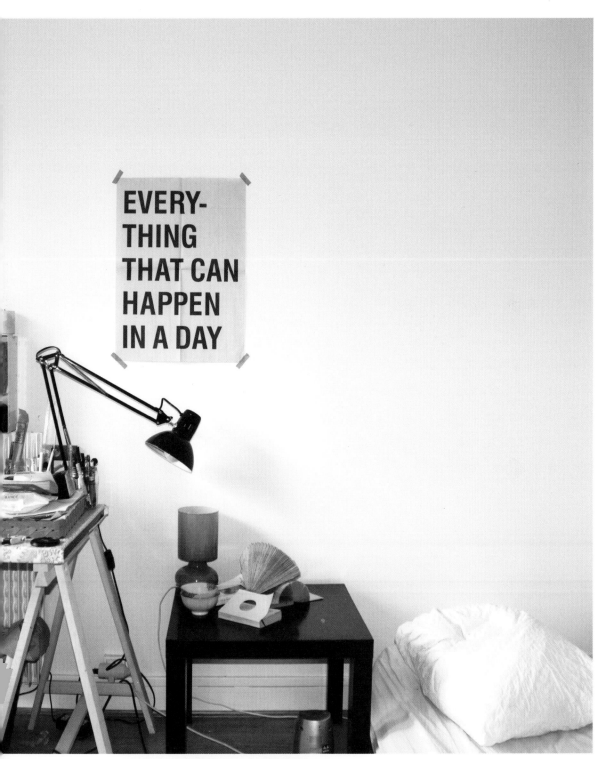

Almost every day over the course of 2009 I sent out an idea to an email list, and posted the same idea on a tumblr blog. Anyone could sign up to receive the emails, and anyone could follow the blog (or use the blog as an archive to find previously sent ideas). The ideas printed in this book are a selection from this project, and the photographs were shot by some of the people following the project (including myself). No "central" website was created to host documentation of the ideas. The intent was to disseminate the ideas outward, to send them away and to see (or not see) what happens. Another intent was that in the act of emailing the ideas out, I would be giving them away (with an emphasis on the giving). In the original description for the project, I called these ideas "open source," with the hopes that people would not consider them my ideas, but everyone's ideas. If people did them, they wouldn't be doing them to complete one of my ideas, but do them for the sake of the idea. And also, that people could change them to fit their own situation, or be inspired to think of something different. The title, Everything That Can Happen in a Day, comes from a poster I had made a few years earlier (my friend Miya Osaki designed it). I thought this was a nice string of words to open your eyes to in the morning. Its meaning would slowly come as your awareness slowly arrived from its waking state. What will happen today? What can happen today? What can I make happen today? What will I make happen today?

DAVID HORVITZ, 2010

WRITE EVERYTHING THAT CAN HAPPEN IN A DAY ON A PIECE OF PAPER. HANG THE PAPER SO THAT IT IS VISIBLE FROM YOUR BED. WHEN YOU OPEN YOUR EYES IN THE MORNING, LOOK AT IT AND THINK ABOUT WHAT WILL HAPPEN TODAY.

SET YOUR ALARM CLOCK ONE MINUTE EARLIER THAN YOUR NORMAL WAKE UP TIME.

GO ON A WALK WITH A POSTAL WORKER AS THEY DELIVER THE DAY'S MAIL. IF THEY DO NOT WANT TO BE WALKED WITH, FOLLOW THEM FROM A FEW HOUSES BEHIND.

LOCATE THE TALLEST BUILDING IN YOUR HOME-TOWN. WRITE A PROFESSIONAL AND COURTEOUS LETTER TO THE OWNER OF THIS BUILDING. ASK IF YOU MAY WATCH THE SUNSET FROM THE ROOF. SEND A SMALL GIFT WITH THE LETTER TO BETTER YOUR CHANCES OF A POSITIVE RESPONSE.

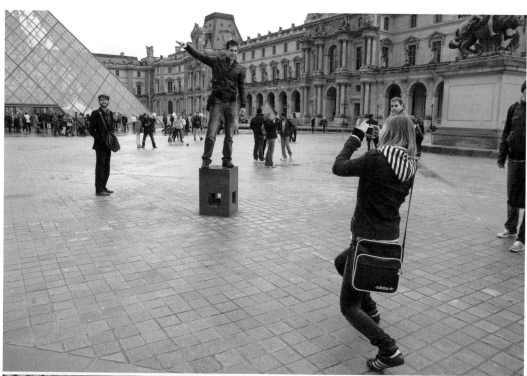

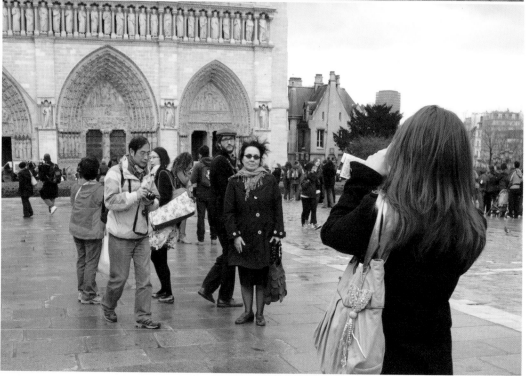

GO TO A POPULAR TOURIST DESTINATION. PLACE YOURSELF IN THE BACKGROUNDS OF AS MANY TOURIST PHOTOGRAPHS AS YOU CAN. THINK ABOUT HOW YOU WILL BECOME PART OF OTHER PEOPLE'S MEMORIES.

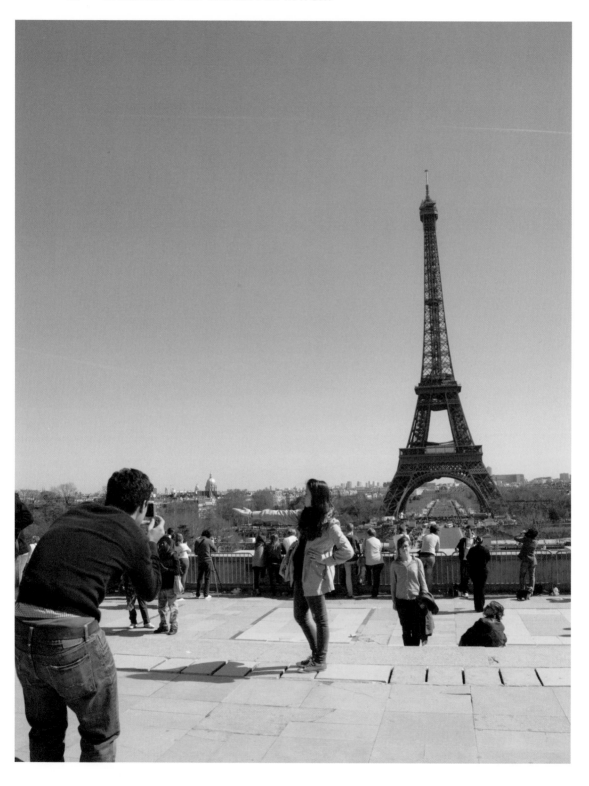

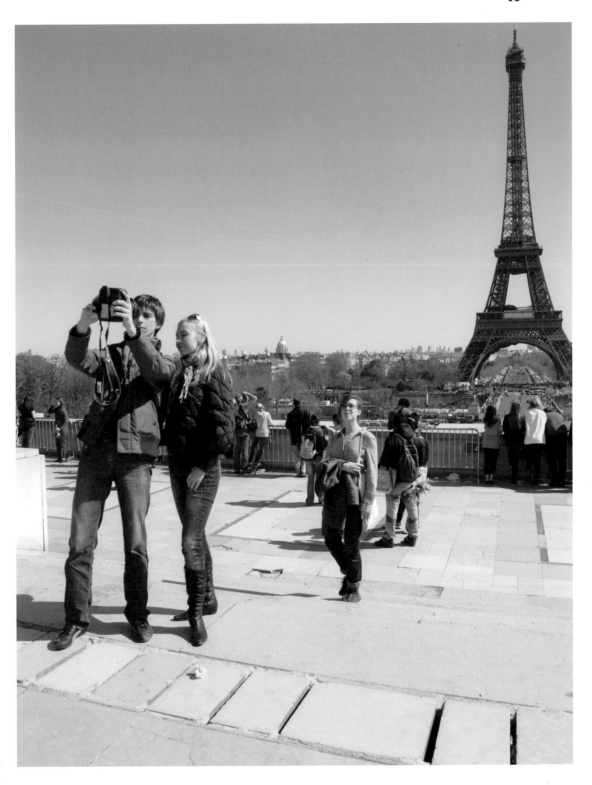

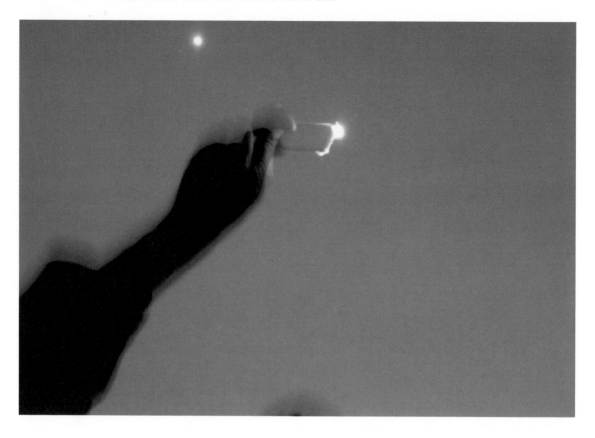

ON THE NIGHT OF A FULL MOON, LIGHT A MATCH AND HOLD IT UP TO THE SKY. MAKE A PHOTOGRAPH SO THAT THE FLAME LOOKS LIKE A SECOND MOON.

FOR BOOKS THAT YOU READ WHEN YOU ARE TRAVELING, KEEP ALL TRAVEL DOCUMENTS IN THE PAGES OF THE BOOK. WHEN YOU OPEN THE BOOK IN THE FUTURE YOU WILL KNOW WHERE IT HAS BEEN.

WALK IN ONE DIRECTION FOR AN ENTIRE DAY, FROM SUNRISE TO SUNSET. WHEN YOU BEGIN YOUR WALK PICK UP A ROCK. WHEN YOU ARE DONE, PUT THE ROCK DOWN. THINK ABOUT HOW THE ROCK WAS DISPLACED BY THE DISTANCE OF ONE DAY (A DISTANCE OF TIME, AS OPPOSED TO A DISTANCE OF SPACE).

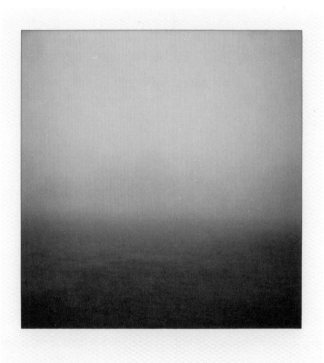

WITH A FRIEND, GO TO A GRASSY FIELD ON A FOGGY DAY. TAKE TURNS WALKING AWAY FROM EACH OTHER, SO THAT YOU MAY WATCH EACH OTHER DISAPPEAR INTO THE FOG.

FLY A KITE IN FRONT OF A BILLBOARD TO DISTRACT PEOPLE'S ATTENTION AWAY FROM THE BILLBOARD.

GO TO THE BUS STOP CLOSEST TO YOUR HOUSE. GET ON THE FIRST BUS. RIDE IT TO THE END. STAY ON THE BUS AS IT TURNS AROUND. RIDE TO THE END AGAIN. STAY ON AGAIN. RIDE TO THE STOP YOU FIRST GOT ON. GET OFF AND WALK HOME.

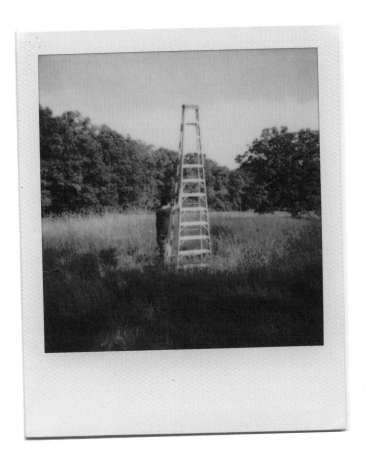

SET UP A LADDER SOMEWHERE. CLIMB TO THE TOP
SO YOU CAN HAVE A CLOSER LOOK AT THE SKY.

MAIL ENVELOPES TO FAKE ADDRESSES IN DIFFERENT COUNTRIES AROUND THE WORLD. IF ALL GOES WELL, THE LETTER WILL ARRIVE IN THE COUNTRY, AND THEN BE RETURNED BECAUSE THE ADDRESS IS FAKE. COLLECT THESE ENVELOPES THAT HAVE TRAVELED AROUND THE WORLD AND BACK.

FAX THE FOLLOWING NOTE TO RANDOM BUSINESSES: TODAY'S SUNSET IS AT (INSERT THE TIME OF THE DAY'S SUNSET IN THE AREA THAT YOU ARE SENDING THE FAX TO). MAYBE THE PERSON WHO FINDS THE FAX WILL GO AND WATCH THE SUNSET THAT EVENING. YOU WILL HAVE INFLUENCED THE OUTCOME OF THEIR DAY. IF THEY DON'T, THEY WILL AT LEAST HAVE TO THINK ABOUT IT FOR A SECOND.

PUT AN ICE CUBE ON YOUR HAND. WATCH IT MELT. TRY NOT TO THINK ABOUT ANYTHING ELSE. WATCH IT UNTIL IT DISAPPEARS.

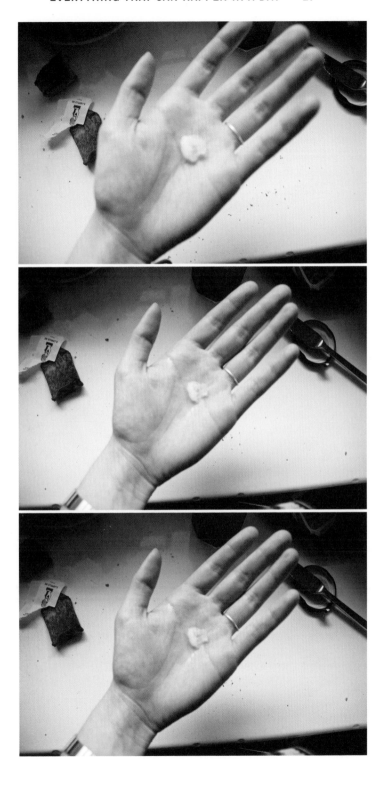

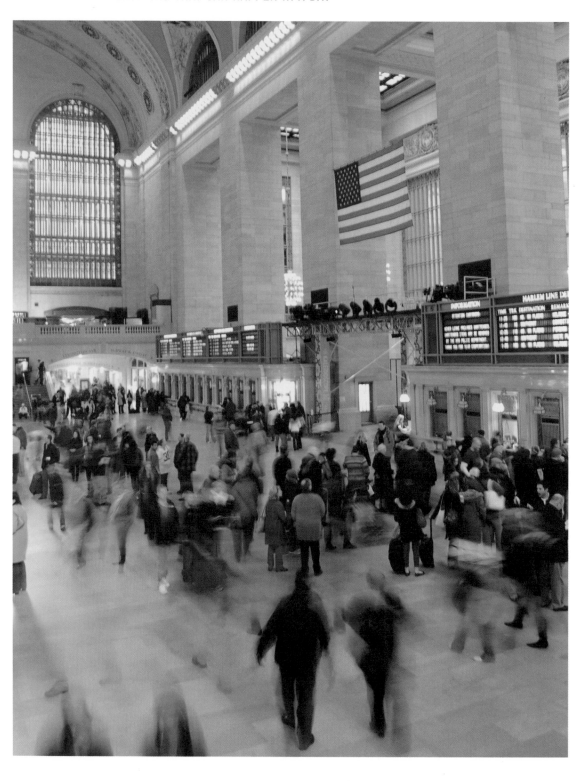

AT THE BUSIEST TIME OF THE DAY GO TO THE BUSIEST PART OF A CITY. AN EXAMPLE WOULD BE GRAND CENTRAL STATION IN NEW YORK CITY AT RUSH HOUR. WALK AROUND AIMLESSLY AT THE SAME SPEED AS EVERYONE ELSE. INSTEAD OF WALKING AWAY FROM THE CROWD, WALK IN CIRCLES THROUGH IT. IF THERE ARE ENOUGH PEOPLE AROUND, NO ONE WILL KNOW YOU ARE WALKING IN CIRCLES. CONTINUE TO WALK AIMLESSLY FOR HOWEVER LONG YOU WANT.

HANG A PHOTO EXHIBITION INSIDE A PHONE BOOTH.

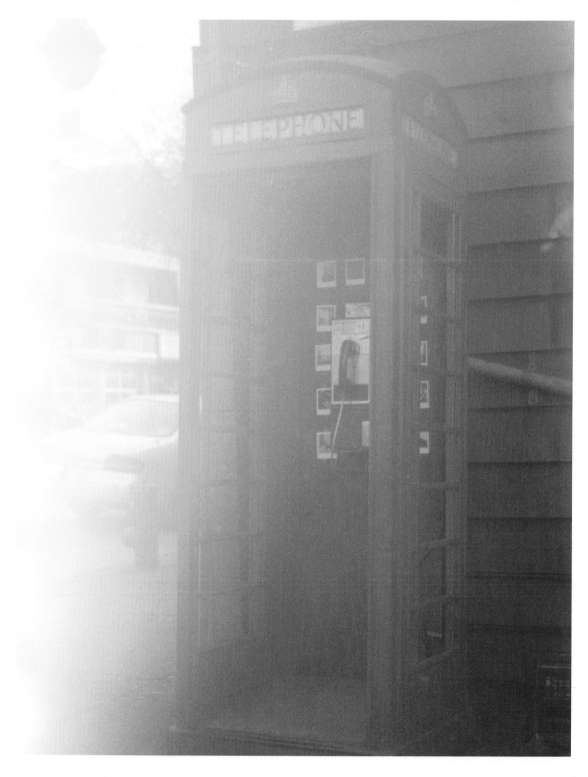

FIND A PATH OF FOOTPRINTS IN THE SAND AT THE BEACH. PUT YOUR FEET INSIDE THE FOOTPRINTS AND WALK THE ENTIRE DISTANCE OF THIS UNKNOWN PERSON'S WALK. THE IDEA IS NOT JUST TO PUT YOUR FEET INSIDE SOMEONE'S FOOTPRINTS, BUT TO REENACT THEIR WALK. TO REPEAT A PHYSICAL MOVEMENT OF AN UNKNOWN PERSON. TO BECOME, BRIEFLY, THIS UNKNOWN PERSON.

AFTER STARING AT A COMPUTER SCREEN FOR TOO LONG, GO OUTSIDE AND STARE AT THE SKY. THIS WILL BE GOOD FOR YOUR EYES.

ACQUIRE PACKETS OF FLOWER SEEDS OF YOUR FAVORITE FLOWERS. PLACE THE SEEDS INCONSPICUOUSLY IN THE POCKETS OF PANTS FOR SALE IN DEPARTMENT STORES. THIS IS TO SPREAD THE SEEDS.

ON A DOLLAR BILL WRITE: A SMALL DISTRACTION INTERRUPTING YOUR EVERYDAY ROUTINE.

TAKE A PHOTOGRAPH OF YOUR HEAD INSIDE A FREEZER. UPLOAD THIS PHOTO TO THE INTERNET. TAG THE FILE WITH 241543903. IF YOU SEARCH FOR THIS TAG, ONLY PHOTOS OF HEADS IN FREEZERS WILL APPEAR.

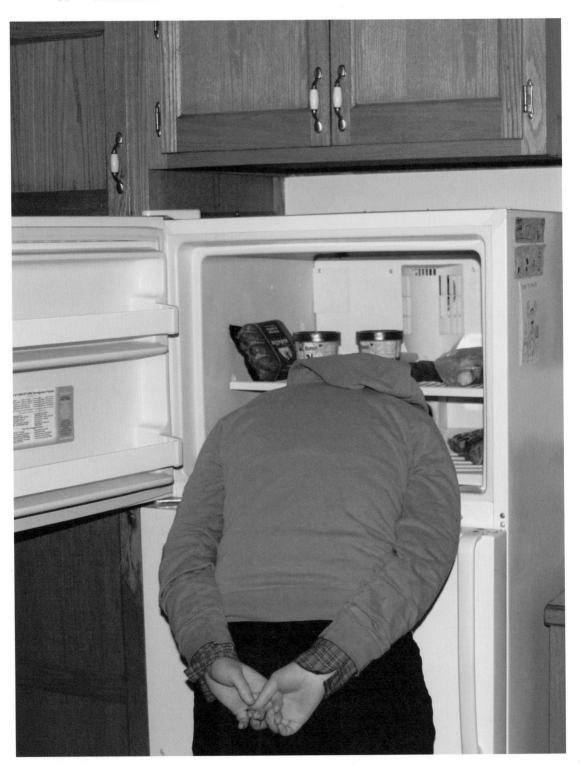

MAIL A DISPOSABLE CAMERA INSIDE A CLEAR ZIPLOC BAG. ON ONE SIDE OF THE BAG WRITE THE ADDRESS WITH A SHARPIE AND PUT THE STAMPS. ON THE OTHER SIDE OF THE BAG WRITE THE FOLLOWING NOTE: DEAR POSTAL WORKER WHO IS HELPING IN THE SHIPPING OF THIS PACKAGE. FIRST OFF, I'D LIKE TO THANK YOU. SECOND, PLEASE TAKE THE CAMERA OUT OF THIS BAG AND TAKE A FEW PHOTOS. WHEN YOU ARE DONE, PUT THE CAMERA BACK IN THE BAG AND CONTINUE ITS DELIVERY. IF YOU ARE THE LAST PERSON DELIVERING THIS BAG, PLEASE FINISH OFF THE ROLL IF IT ISN'T ALREADY DONE. THANKS AGAIN, (YOUR NAME HERE).

MAKE A WIKIPEDIA PAGE ABOUT YOUR MOTHER.

MAKE A COLLECTION OF SAND FROM DIFFERENT BEACHES AROUND THE WORLD BY WRITING TO RESORT HOTELS AND ASKING THEM TO SEND YOU AN ENVELOPE OF SAND. TELL THEM YOU RECENTLY STAYED AT THE HOTEL AND THAT YOUR SAND WAS LOST WHEN YOU TRAVELED HOME.

FOR AN ENTIRE DAY, GIVE A FLOWER TO EVERY CASHIER YOU PURCHASE SOMETHING FROM.

START A DREAM JOURNAL USING AN ANONYMOUS BLOG. DON'T TELL ANYONE ABOUT IT OR PROMOTE IT IN ANY MANNER. EVERY MORNING TYPE YOUR DREAMS. WHEN YOU WRITE ABOUT PEOPLE INCLUDE THEIR FULL NAME. IF THESE PEOPLE EVER SEARCH FOR THEIR NAMES ONLINE, YOUR DREAM JOURNAL WILL APPEAR IN THE RESULTS. THIS WILL BE THE ONLY WAY PEOPLE WILL FIND YOUR DREAM JOURNAL.

THE NEXT TIME YOU ARE IN AN AIRPLANE CLOSE YOUR EYES AND IMAGINE THE AIRPLANE WAS NOT THERE. IMAGINE THAT YOU ARE, IN A SITTING POSITION WITH NOTHING ELSE AROUND YOU BUT THE SKY, FLYING AT A SPEED OF HUNDREDS OF MILES AN HOUR.

SPEND AN ENTIRE DAY NOT KNOWING WHAT TIME IT IS.

SNEAK INTO A CAR SALES LOT WITH ONE OF THOSE HUGE BALLOONS FLYING IN THE SKY. WHEN NO ONE IS LOOKING, AND WHEN YOU HAVE A CLEAR GETAWAY PATH, CUT THE BALLOON FREE AND RUN AWAY. AS YOU ARE RUNNING, THINK ABOUT ALL THE PEOPLE WHO ARE TRANSFIXED BY THE BALLOON GOING UP INTO THE SKY. KEEP RUNNING UNTIL YOU ARE SAFE.

IN A PUBLIC PLACE, LINE UP TEN ORANGES AND
LEAVE THEM.

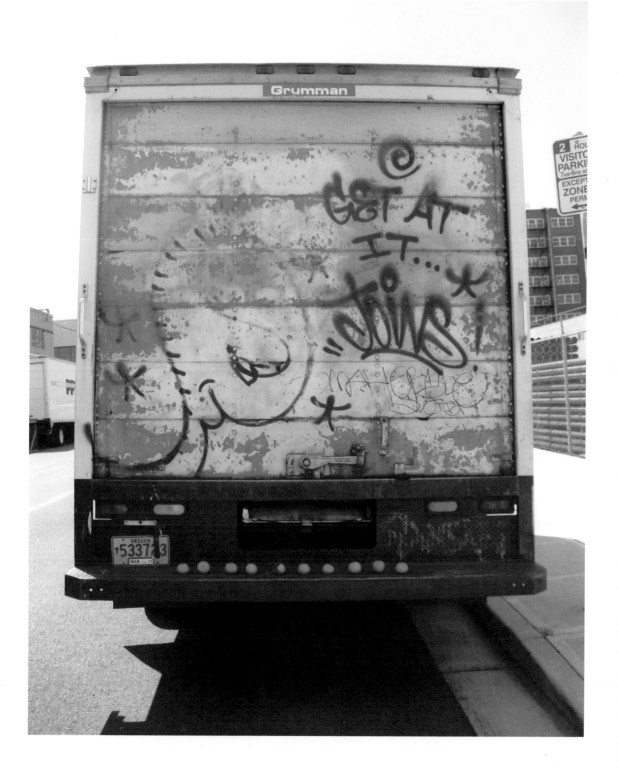

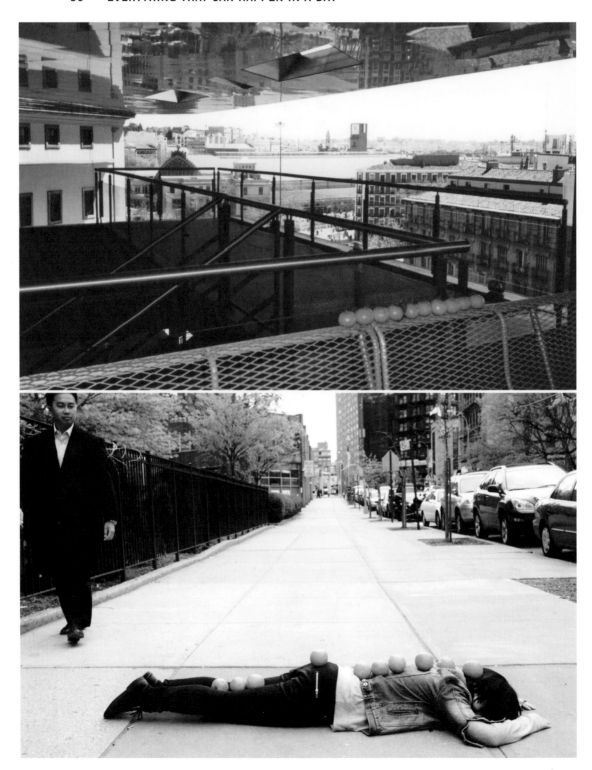

FIND A POSTCARD OF A BOAT AND MAIL IT TO A LOCATION ACROSS AN OCEAN.

WRITE A BRIEF LETTER ABOUT ANY TOPIC. TRANSLATE THE LETTER INTO ANOTHER LANGUAGE USING AN ONLINE TRANSLATOR. PICK A COUNTRY THAT SPEAKS THIS LANGUAGE AND MAIL THE LETTER TO ITS PRESIDENT OR PRIME MINISTER.

TAKE A SERIES OF PHOTOGRAPHS OF A SETTING SUN. PRINT AND FRAME EACH PHOTOGRAPH. NOW PICK ANY STREET IN A TOWN. GO DOWN THE STREET AND ASK DIFFERENT BUSINESSES IF THEY WOULD LIKE TO HAVE AND HANG THE PHOTOGRAPH IN THEIR STORE. GIVE THEM ALL AWAY IN SEQUENTIAL ORDER. WHEN YOU ARE DONE, YOU WILL BE ABLE TO WALK DOWN THE STREET AND SEE THE SUN SLOWLY SETTING IN DIFFERENT STORES.

ASK A WAR VETERAN TO WRITE AN APOLOGY LETTER TO THE COUNTRY THEY HAD FOUGHT.

ACQUIRE A HIGHLY PRICED BOTTLE OF WATER. POUR IT OUT ON THE ROOTS OF A TREE NEARBY.

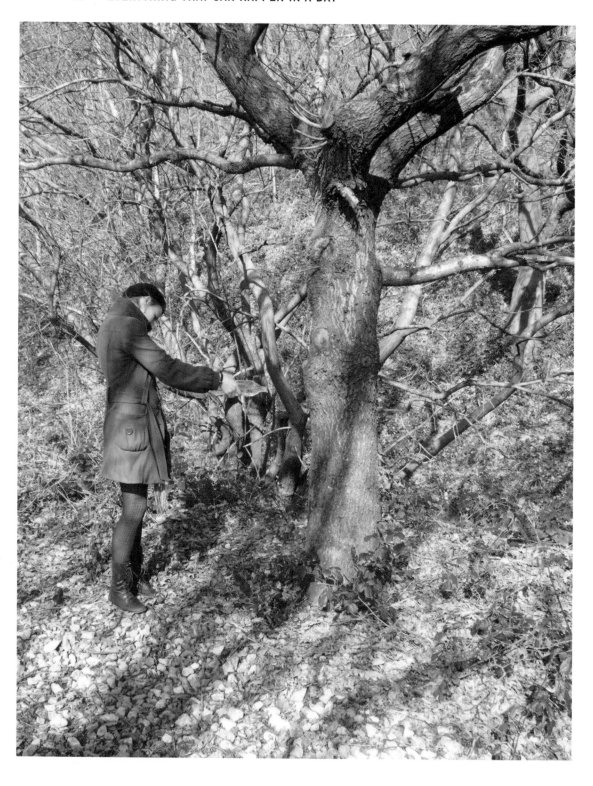

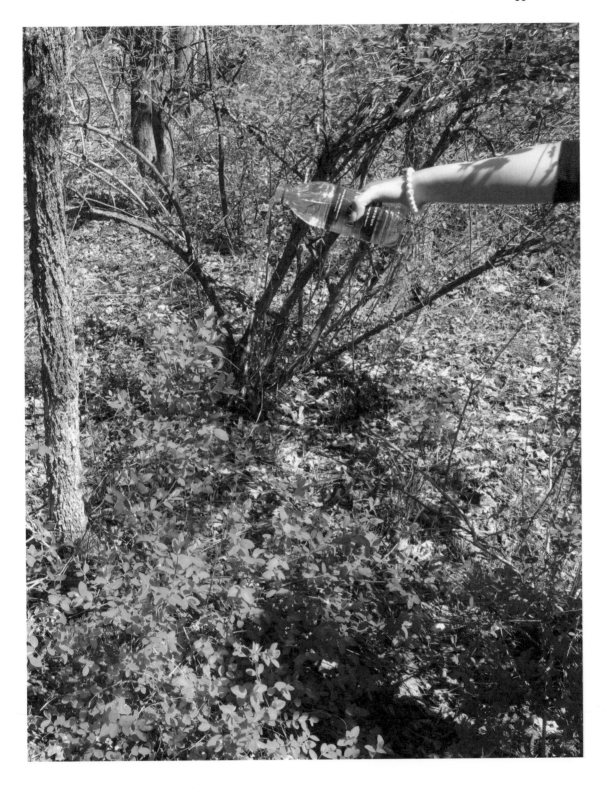

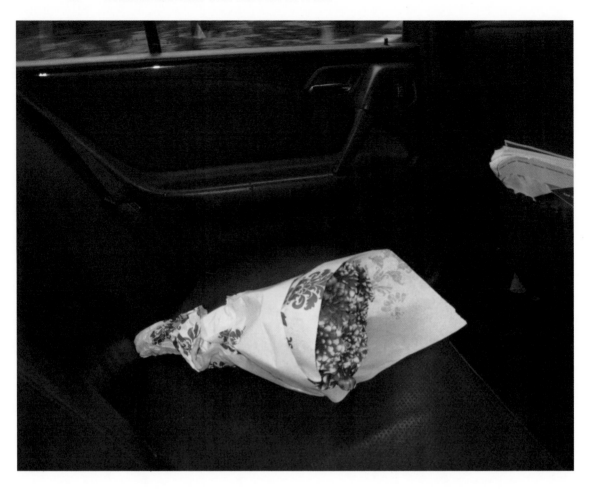

LEAVE A BOUQUET OF FLOWERS IN A TAXI FOR THE NEXT PERSON.

CALCULATE HOW FAR AWAY THE PACIFIC OCEAN IS FROM YOUR BEDROOM. WRITE THE FOLLOWING ON YOUR BEDROOM WALL: THE PACIFIC OCEAN IS (ENTER CALCULATED DISTANCE) FROM HERE.

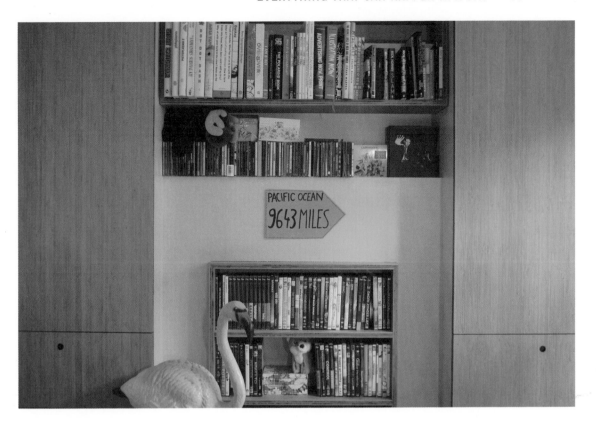

DURING A TIME YOU ARE UNDER SOMEONE ELSE'S AUTHORITY (LIKE AT WORK OR SCHOOL), DO ABSOLUTELY NOTHING FOR ONE MINUTE. DO THIS NOT OUT OF LAZINESS OR APATHY, BUT AS AN ACTIVE CHOICE TO DO NOTHING WHEN SOMEONE WANTS YOU TO DO SOMETHING.

GO TO A MUSEUM THAT CONTAINS OLD PAINTINGS. FIND A PAINTING THAT YOU'VE NEVER LOOKED AT BEFORE. LOOK AT IT FOR ONE HOUR.

USING A STANDARD SIZED PIECE OF PAPER, MAKE A SIGN THAT STATES: DOESN'T THE SKY LOOK NICE RIGHT NOW? MAKE IT PLAIN AND SIMPLE, AVOID UNNECESSARY FANCINESS. HANG THIS UP ON A TELEPHONE POLE IN A PUBLIC LOCATION.

LOCATE THE EXACT OPPOSITE SIDE OF THE EARTH FROM WHERE YOU ARE NOW. MAKE A PHOTOGRAPH POINTING TO THIS LOCATION ON A MAP. HANG THIS ON YOUR WALL TO REMIND YOU WHERE THE FARTHEST DISTANCE AWAY FROM YOU ON EARTH IS.

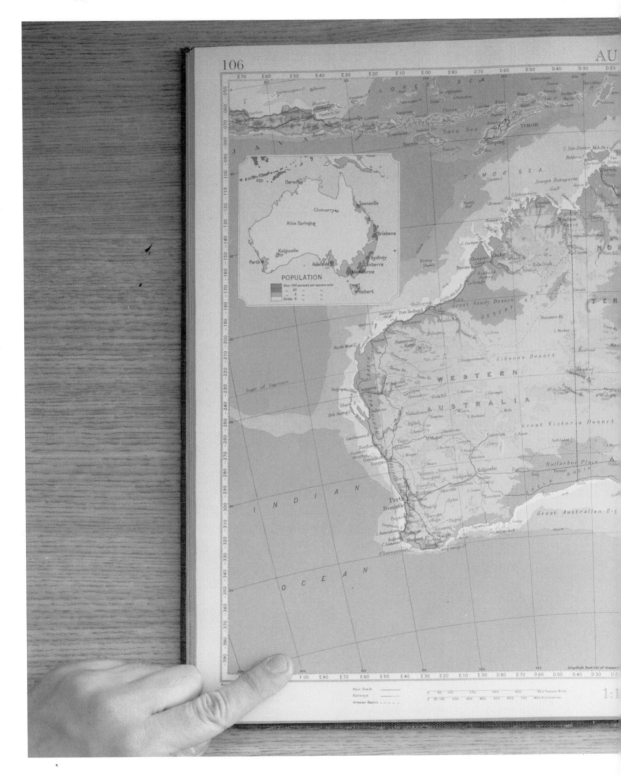

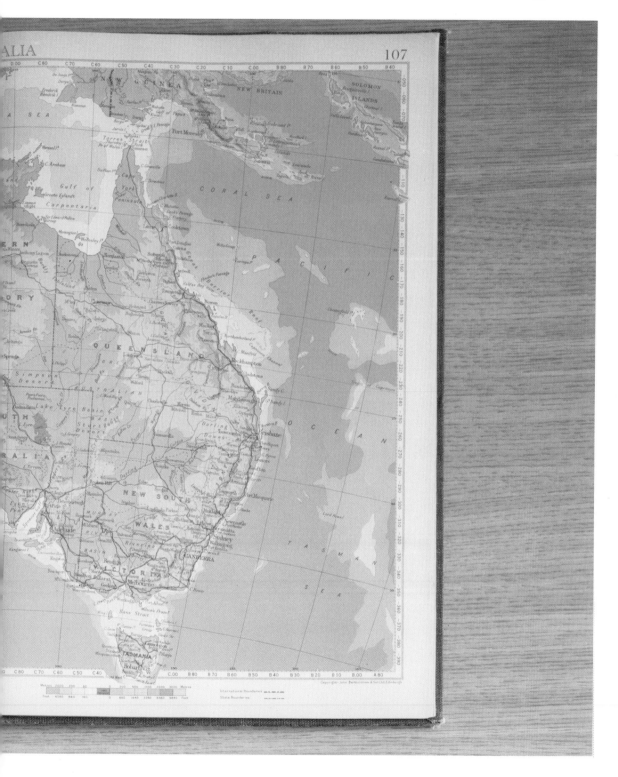

TAKE A SELF-PORTRAIT PHOTOGRAPH WITH YOUR HEAD IN A TREE.

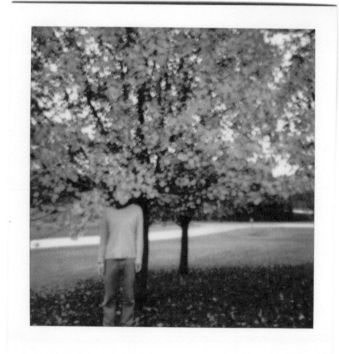

EITHER IN A 24 HOUR LAUNDROMAT OR A BANK THAT HAS 24 HOUR INDOOR ATM ACCESS, HOLD A PUBLIC READING NEXT TIME IT RAINS. READ RAY BRADBURY'S SHORT STORY "ALL SUMMER IN A DAY."

ON A CLEAR NIGHT AFTER IT RAINS IN A CITY, WHEN ALL THE POLLUTION HAS BEEN WASHED FROM THE SKY, SHUT OFF EVERY LIGHT IN THE CITY AND SIT IN THE MIDDLE OF A MAJOR BOULEVARD AND STARE AT THE STARS. I DON'T KNOW HOW YOU WILL DO THIS, BUT TRY.

GO TO A MUSEUM THAT HAS ONE OF MARCEL DUCHAMP'S "FOUNTAINS." WHEN THE GALLERY ATTENDANT IS NOT LOOKING, PUT YOUR FACE INSIDE THE URINAL.

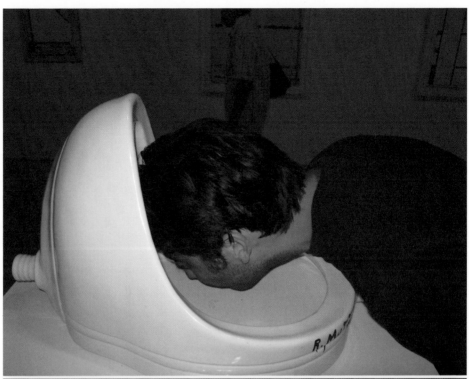

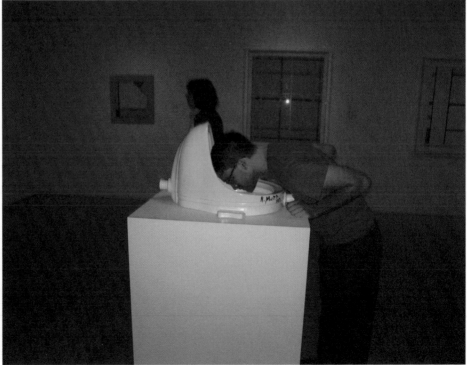

MAKE A SERIES OF PHOTOGRAPHS OF YOUR BREATH ON A MIRROR.

WITH A PIECE OF WHITE CHALK, WRITE ON A WHITE WALL: I DON'T KNOW. WHEN YOU FINALLY KNOW WHAT YOU DID NOT KNOW, WIPE AWAY THE CHALK.

WHEN YOU ARE FEELING SAD GO AND FIND A TREE OR A WALL. DO A HANDSTAND AGAINST THE TREE OR WALL. LET THE SADNESS DRAIN OUT OF YOU.

CONTACT A PERSON WHO LIVES ON THE OPPOSITE SIDE OF THE EARTH FROM YOU. ASK THEM TO TAKE A PHOTOGRAPH OF THE SKY FROM WHERE THEY LIVE. TAKE YOUR OWN PHOTOGRAPH AT THE SAME TIME AND HANG THE TWO TOGETHER. THINK OF IT AS A VIEW OF THE ENTIRE SKY AT ONE MOMENT.

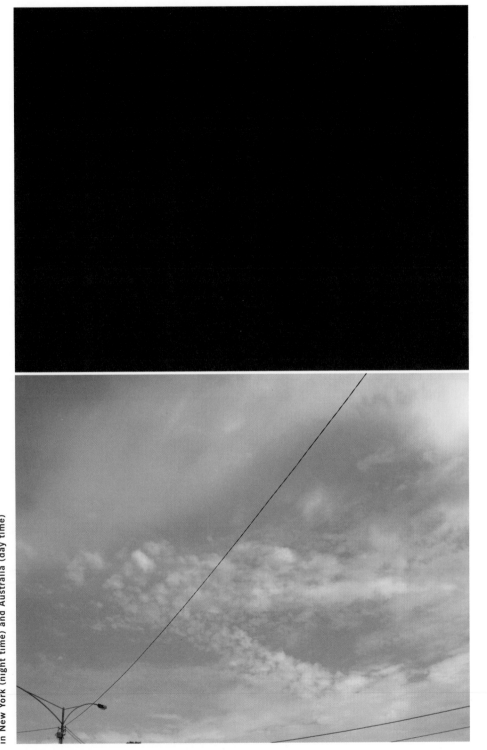

A photograph of the sky at the exact same time on April 8, 2010 in New York (night time) and Australia (day time)

MAKE A PHOTO EXHIBITION OF SUNSETS FROM IRAQ FOUND ON THE INTERNET. PRINT THE PHOTOGRAPHS AND HANG THEM IN YOUR BEDROOM.

LEAVE A PIECE OF PAPER IN THE RAIN. AFTER IT RAINS, BRING IT INSIDE AND LET IT DRY. IN THE SAME WAY A PHOTOGRAPH IS CONSIDERED A RECORD OF LIGHT ON A SURFACE, CONSIDER THIS A RECORD OF RAIN ON A SURFACE. MAKE A COLLECTION OF DIFFERENT RAINY DAYS.

ORGANIZE A CHINESE TAKE-OUT PARTY. HAVE THE GUESTS BRING A DISH FROM THE CHINESE TAKE-OUT RESTAURANT CLOSEST TO THEIR HOME. MARK ON A MAP WHERE THE FOOD CAME FROM. COMBINE ALL THE RICE IN ONE POT.

MAIL A GIFT TO BOTH OF YOUR NEIGHBORS (WHO LIVE ON THE LEFT AND THE RIGHT OF YOU). FOR THE GIFT YOU MAIL TO THE NEIGHBOR ON YOUR LEFT, WRITE THE ADDRESS OF THE NEIGHBOR ON THE RIGHT AS THE RETURN ADDRESS. ON THE GIFT TO THE NEIGHBOR ON THE RIGHT, USE THE NEIGHBOR ON THE LEFT'S ADDRESS AS THE RETURN ADDRESS. FROM YOUR POSITION IN THE MIDDLE, TRY TO SEE IF ANYTHING HAPPENS.

GET A CLOCK. SET THE TIME FOR THE TIME ZONE OF UTC–2 (UNIVERSAL COORDINATED TIME –2). THIS IS THE TIME FOR SOMEWHERE ROUGHLY IN THE MIDDLE OF THE ATLANTIC OCEAN (ALSO GOING THROUGH A FEW ISLANDS AND PARTS OF BRAZIL). KEEP THIS SOMEWHERE SO THAT YOU CAN ALWAYS REFER TO WHAT TIME IT IS IN THE MIDDLE OF THE OCEAN.

MAKE A SELF-PORTRAIT PHOTOGRAPH IN WHICH YOU ARE HOLDING A SIGN THAT SAYS HELLO GEORGIA. FRAME IT. PUT IT SAFELY IN A PACKAGE. MAIL THE PACKAGE TO A FAKE ADDRESS IN THE UNITED STATES. DO NOT USE A RETURN ADDRESS. CONTENTS OF UNDELIVERABLE MAIL THAT CANNOT BE FORWARDED ARE REMOVED FROM THEIR PACKAGES. CORRESPONDENCE IS DESTROYED, AND OBJECTS ARE SENT TO ATLANTA, GEORGIA, TO BE AUCTIONED OFF. HOPEFULLY THIS PHOTOGRAPH WILL END UP IN GEORGIA.

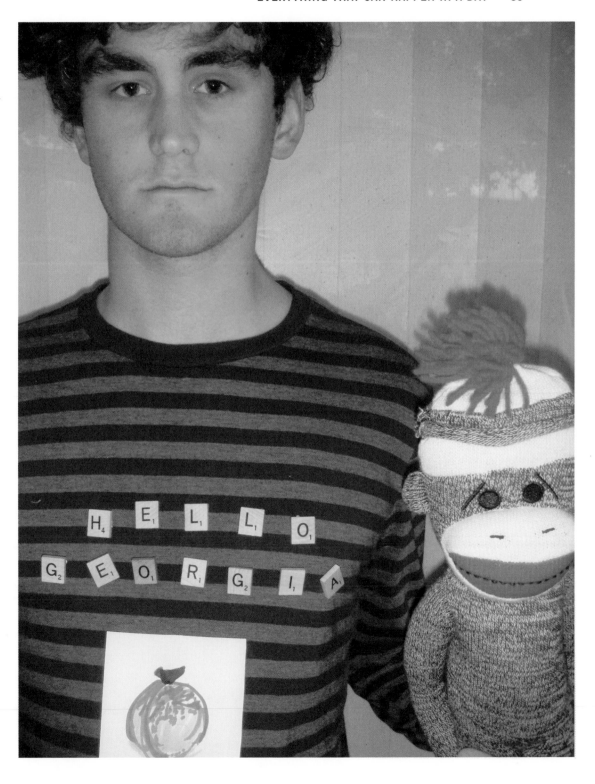

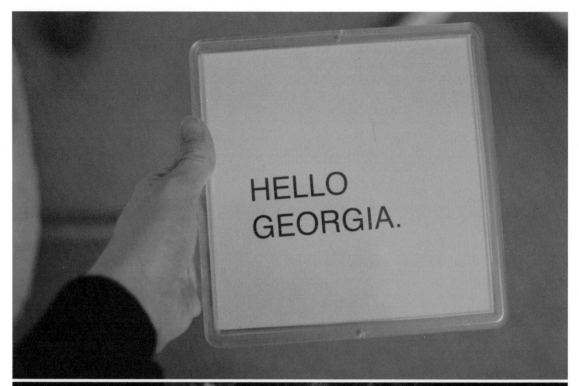

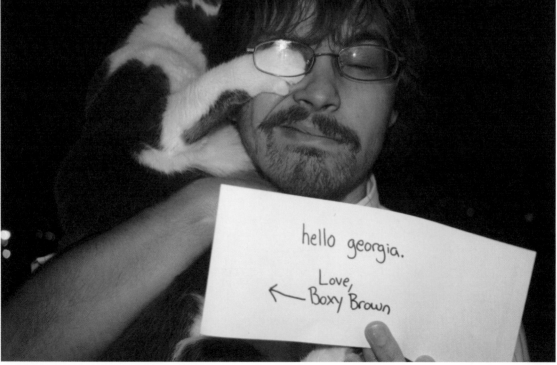

FIND A COMMENT FIGHT ON A YOUTUBE VIDEO. READ THESE COMMENTS WITH YOUR FRIENDS IN AN OVERLY THEATRICAL MANNER.

MAKE A ONE MINUTE AND TWENTY-TWO SECOND SILENT VIDEO OF YOUR FACE WITH YOUR EYES CLOSED. UPLOAD IT TO YOUTUBE WITH THE TITLE: 1:22 EYES CLOSED.

SCATTER SUGAR OR SALT CRYSTALS ACROSS THE TOP OF A PHOTOCOPY MACHINE. KEEPING THE COVER UP (WHICH MAKES THE NEGATIVE SPACE BLACK), MAKE A PHOTOCOPY. CALL THIS A GALAXY. CONTINUE TO MAKE DIFFERENT GALAXIES.

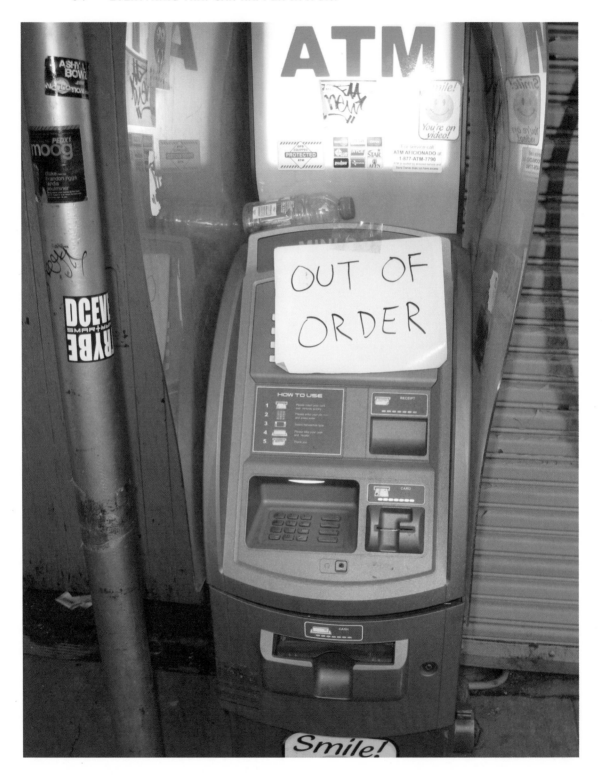

WITH A SHARPIE MAKE A SMALL SIGN THAT SAYS: OUT OF ORDER. TAPE THIS TO AN ATM WHEN NO ONE IS LOOKING.

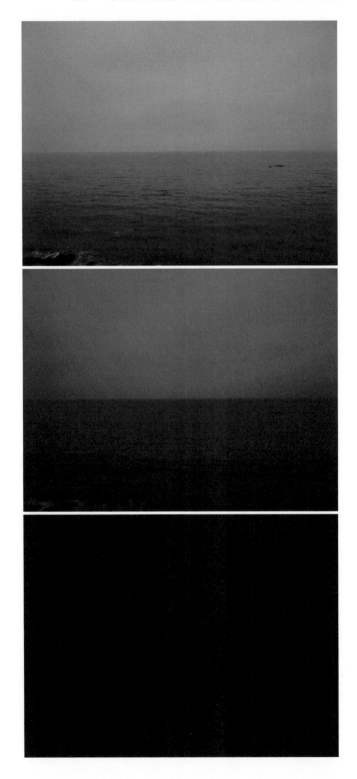

AT SUNDOWN GO TO A PLACE WHERE YOU CAN VIEW THE OCEAN. THE PLACE NEEDS TO BE VERY DARK AND HAVE NO LIGHT POLLUTION. AFTER THE SUN SETS, WATCH THE HORIZON FOR THE REMAINING TIME THERE IS LIGHT IN THE SKY. TRY TO NOTICE THE EXACT MOMENT THE HORIZON DISAPPEARS FROM VISIBILITY, WHEN THE SKY BECOMES INDISCERNIBLE FROM THE SEA.

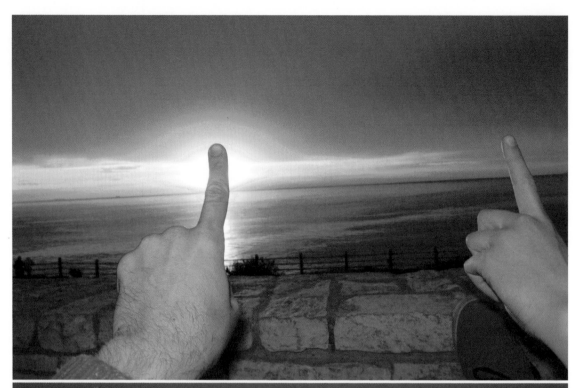

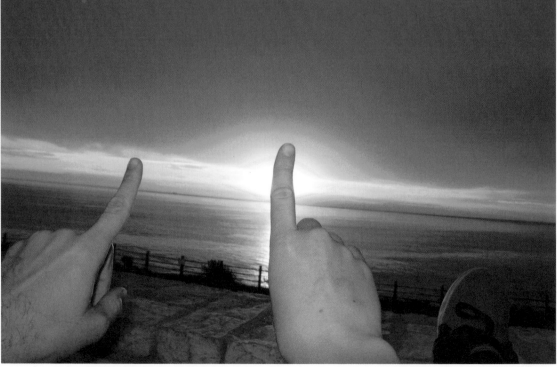

COVER UP THE SUN WITH A FINGER.

CUT A DOLLAR BILL IN HALF. BE VERY PRECISE. METICULOUSLY SEW THE TWO HALVES BACK TOGETHER. PUT THE DOLLAR BACK IN CIRCULATION.

TURN ALL THE SIGNS ON A BULLETIN BOARD AROUND SO THAT ALL THAT SHOWS ARE THE BACKS OF PIECES OF PAPER.

PHOTOGRAPH YOUR FRIENDS CLIMBING OVER FENCES.

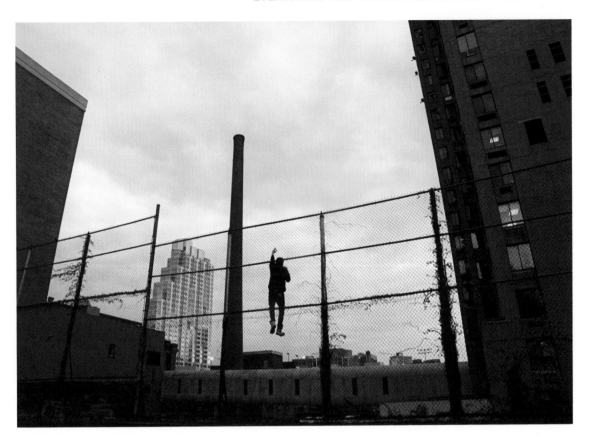

PICK WILDFLOWERS FROM PRIVATE PROPERTY AND GIVE THEM TO A FRIEND.

FIND A NICE LOOKING GLASS BOTTLE. WRITE A LETTER ON A NICE PIECE OF PAPER AND PUT IT IN THE BOTTLE. FLOAT IT IN A PUBLIC FOUNTAIN.

MAKE A SERIES OF PHOTOGRAPHS DOCUMENTING YOUR FRIENDS JAYWALKING.

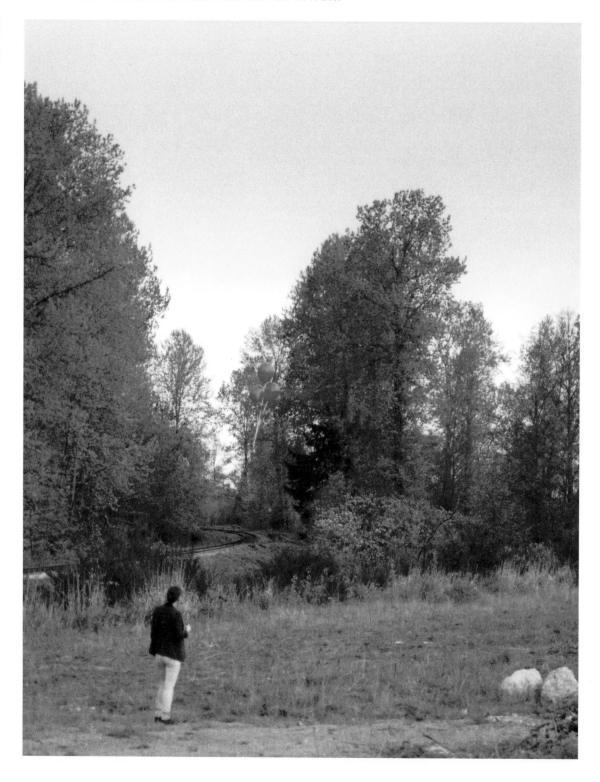

ON A DAY THE SKY LOOKS ESPECIALLY NICE, SHOW YOUR ADMIRATION BY RELEASING A BALLOON WITH A ROSE TIED TO THE END OF THE STRING UP INTO THE CLOUDS.

FIND A LOCAL MAP THAT CONTAINS THE PLACES OF YOUR DAILY ACTIVITIES. FOR ONE WEEK TRACE THE EXACT ROUTE OF YOUR DAILY EXCURSIONS ONTO THE MAP. IF YOU REPEAT A ROUTE, DRAW OVER THE LINE MAKING IT BOLDER. AT THE END OF THIS ACTIVITY EXAMINE THE MARKINGS ON THE MAP. ARE YOU CONFINED TO A LIMITED ROUTINE? IF SO, BREAK THIS ROUTINE.

RENT A POST OFFICE BOX FOR ONE YEAR. EVERY TIME YOU SEE A SUNSET IN THE NEXT 364 DAYS, TAKE A PHOTOGRAPH OF IT AND MAIL IT TO THE P.O. BOX. BEFORE THE YEAR IS UP GIVE THE KEY AWAY AS A GIFT.

MAIL AN ARTWORK THAT YOU MADE TO THE WHITE HOUSE AT 1600 PENNSYLVANIA AVENUE NW, WASHINGTON, DC 20500. MAYBE THEY WILL ACCEPT IT INTO THEIR ART COLLECTION.

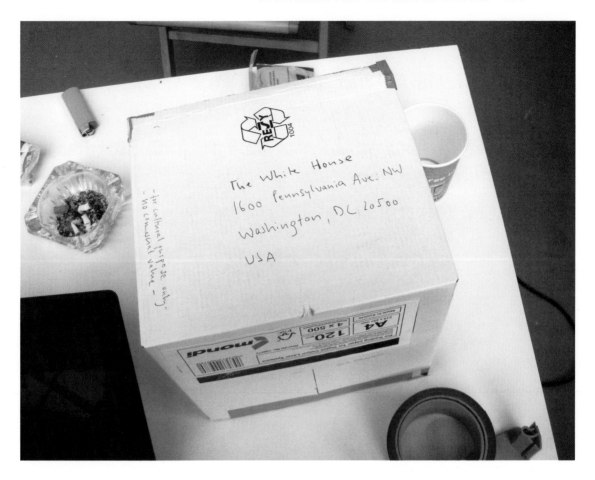

FIND A LEAF ON THE GROUND. PICK IT UP. FIND ANOTHER LEAF ON THE GROUND. PICK IT UP. PUT THE FIRST LEAF EXACTLY WHERE YOU FOUND THE SECOND LEAF. PUT THE SECOND LEAF EXACTLY WHERE YOU FOUND THE FIRST LEAF.

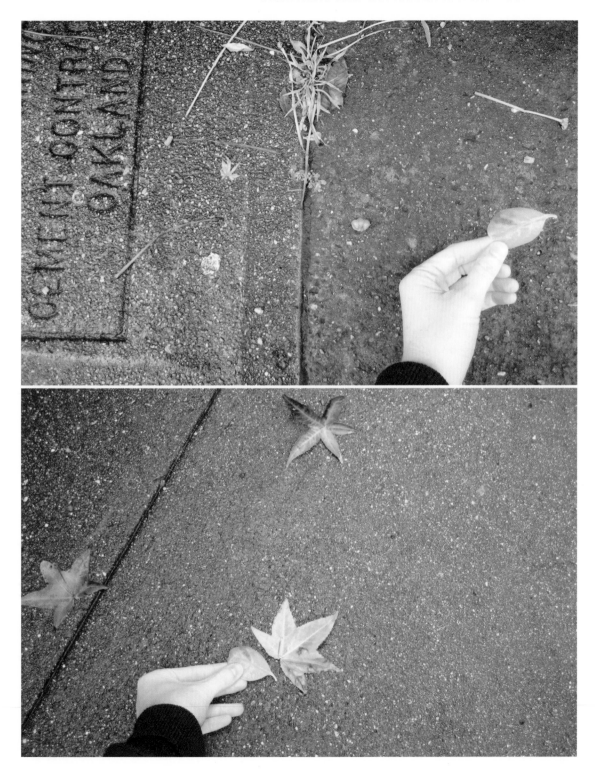

NOTICE THE EXACT MOMENT THE FIRST STAR APPEARS IN THE NIGHT SKY. STAY UP ALL NIGHT. NOTICE THE EXACT MOMENT THE LAST STAR IN THE MORNING SKY DISAPPEARS.

MAKE A SERIES OF PHOTOGRAPHS IN WHICH YOU ARE STANDING ON THE TRUNKS OF FELLED TREES.

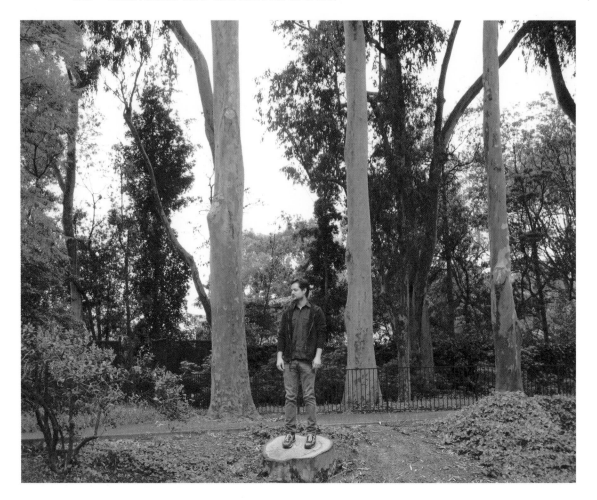

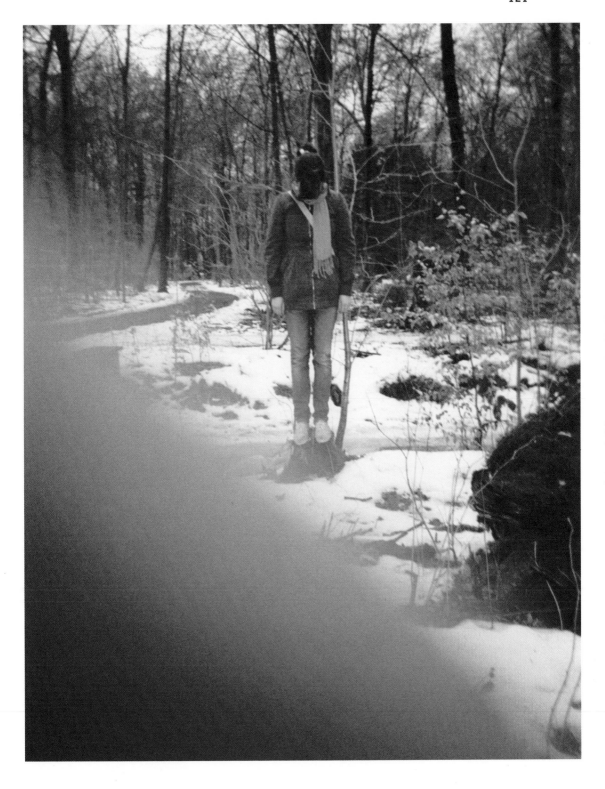

TRY TO GO TO SLEEP WITH YOUR EYES OPEN.

WALK DOWN A STREET YOU HAVE NEVER WALKED DOWN BEFORE.

SHILOH ADERHOLD — 90 (TOP) .

ANONYMOUS — 94, 96, 102–103

HAYLEY AUSTIN (COURTESY OF GOLDEN PARACHUTES, BERLIN) — 54

JONATHAN BARDELLINE — 90 (BOTTOM)

GRAEME BRUCE — 28

MARIE CLEREL — 2–3, 10, 12–13, 27, 77

HERMINE COOREMAN — 63

ALEX FELICITAS — 50 (BOTTOM), 105

FANGJUAN FENG AND DAVID HORVITZ — 81

ROB HALVERSON — 107

DAVID HORVITZ — 14, 18, 22, 38, 60, 68–69, 71, 85 (BOTTOM), 98, 124–125

ALISON KRANZ — 117

JULIANNE LEE — 59, 127

JENNILEE MARIGOMEN — 31, 110

ANNIKA PADOAN — 121

SHANNON PEDIT — 39

STEFAN RIEBEL — 115

HOLLIE ROBSON — 50 (TOP)

ALEX ROSE AND RACHEL REYNOLDS — 85 (TOP)

GARRETT SCHOLBERG — 89

STEPHANIE SIMEK — 49, 51

JOHN SISLEY — 120

ROSIE SMITH — 58, BACK COVER

JAMIE STEWART AND DAVID HORVITZ — 75

JULIA VITER — 37

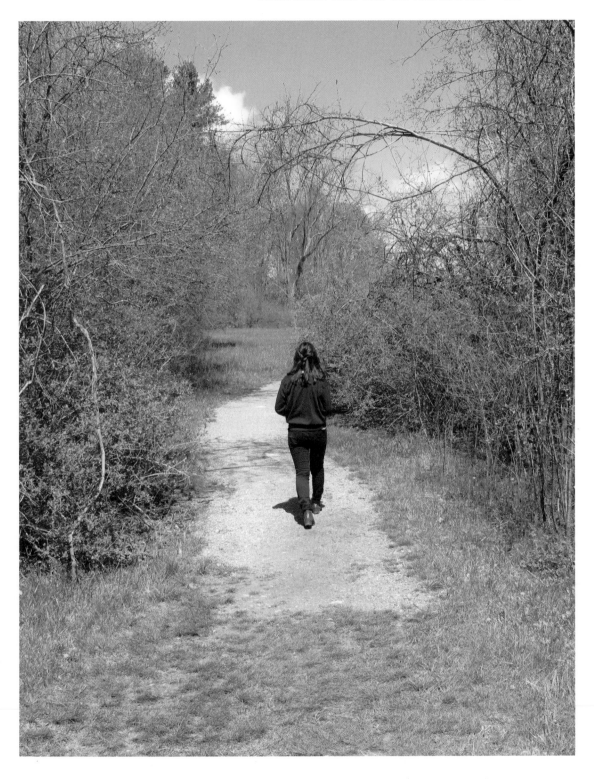

THIS IS FOR OOXE.